Islamic Designs

Diane Victoria Horn

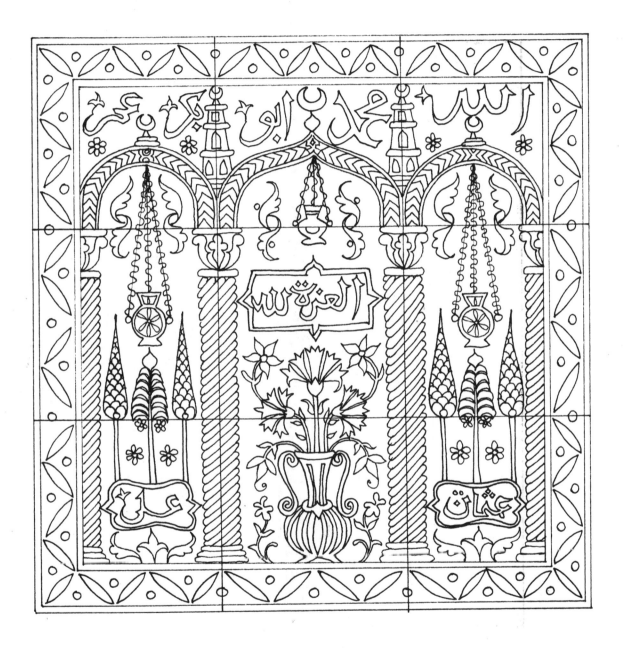

Introduction

THE LEGACIES OF ISLAMIC DESIGNS are traced to the ancient Byzantine empire, heir to the Greco-Roman civilizations. This empire was surrounded by the Mediterranean and the Persian empire, under the elaborate court of the Sasanian dynasty, which extended as far as Central Asia to southwestern Arabia in the Yemen. In the early part of the sixth century, a sequence of events seriously weakened both empires and facilitated the Arabian conquest. The Arabs of the pre-Islamic period were divided into groups of town dwellers living north of the peninsula and beyond in Syria, and the Bedouin living in the Yemen. A caravan route was established from Yemen along the coast of the Red Sea through the cities of Makkah and Medina by way of Gaza to Egypt and Rome. The cultural link which united the townsmen and the Bedouin was the Arabic language.

The year 570 A.D. marks the traditional date of the birth of Muhammad in Makkah. As a young man, he worked with the trading caravans. It was along these routes that Muhammad must have seen objects made and decorated in places as far north as Rome, as far west as Africa and from China in the east. At about the age of forty, Muhammad began to experience revelations that he communicated to his family and the people of Makkah. The words that he received were learned and recorded by his followers. They form the Qur'an, a recitation and reading, which became the holy book of Islam. Arabic, the language of the Qur'an and of formal prayer, contains words that are related to each other by a pattern of units. This linguistic structure may have had an influential role in Islamic designs.

In the beginning, the message of the Prophet Muhammad was not really accepted by all who lived in Makkah. The animosity of the wealthy town dwellers became so intense that in 622 Muhammad and his followers left Makkah for Medina (Madinat al-Nabi), the City of the Prophet. This departure, known as the hijrah, is the date when the Muslim era began. Medina was to be the home of Muhammad until his death in 632. It was there that he structured the new Muslim community, and the basic scheme of Muhammad's house was to become the pattern for the early Islamic masjid (mosque). The courtyard, fountain, the minaret, the Mihrab, tiled walls, prayer rugs, mosque lamps, glass screens and the like were essential features of Islamic architecture and influenced the nature of Islamic art.

To a discerning eye, one of the most striking aspects of Islamic art is the way in which a completely definite style, an entire repertory of motifs and a distinct architectural system became uniquely associated with an idea and a faith. Muslim artists of later centuries did not seek the new and unfamiliar, but rather remained attached to the model whose merit had been sanctioned by time and convention, only seeking to renew its appeal and rejuvenate its character by subtle variations of detail. The adoption of designs, language and script by Muslims from virtually all the known races of man resulted in a basic form of ornament in art that exercised a tremendously unifying effect. Muslim artists and craftsmen from Indonesia, China, Russia, India, Turkey, Spain and North Africa became the great patternmakers of the world.

The distinct features of Islamic art have a certain degree of sameness; and so it is sometimes difficult to assign objects to a specific locality, and even more difficult to date them. The surface decorations used on all objects are two-dimensional with no focal point, and the design possibilities are infinitely extendible. In some cases, the purpose and function of some of the objects are unknown; yet they have distinguishing shapes that are fascinating in themselves. Islamic designs are based on four recurring motifs, but were rendered by artists from varying cultural backgrounds. Because of the vast number of Muslims throughout the world, the incorporation of traditional cultural motifs is the norm rather than the exception. Moorish artisans living in Spain for 781 years, during the Middle Ages, often incorporated western European heraldic and folkloric figures, while the Persians taught artists of India the use of motifs from "Paradise," or Heaven, with flowing water, lush gardens and a multitude of animals. Muslim artists from Asia used dragons, while those living in the Maghrib (North Africa: "Islam Farthest West") used camels. The designs may vary from one area to the next, but the calligraphy is always devoted to the Arabic alphabet.

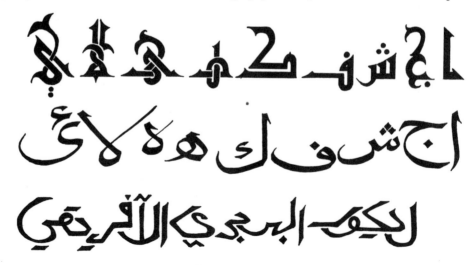

Calligraphy

"Handwriting is jewelry fashioned by the hand from the pure gold of the intellect. It is also a brocade woven by the pen with the thread of discernment." These metaphors of the tenth century reflect the preeminent status of calligraphy in the Islamic world. By transcribing words in a flowing hand, the calligrapher emphasized the meaning of the words with his artistry.

Calligraphy evolved as the archetypal art of Islam partially because of the tremendous flexibility and visual potential of the Arabic alphabet. Its twenty-eight letters derive from a limited number of basic shapes and can be executed in a wide range of styles.

Calligraphy was not confined to the manuscript page but was adapted for use on buildings, textiles and objects of all kinds. The words were rendered in straight lines, circles, squares and interlaced patterns. Individual letters were embellished with leaf forms, braided into knots or animated with figures. This decorative repertoire forms one of the great achievements of Muslim artists.

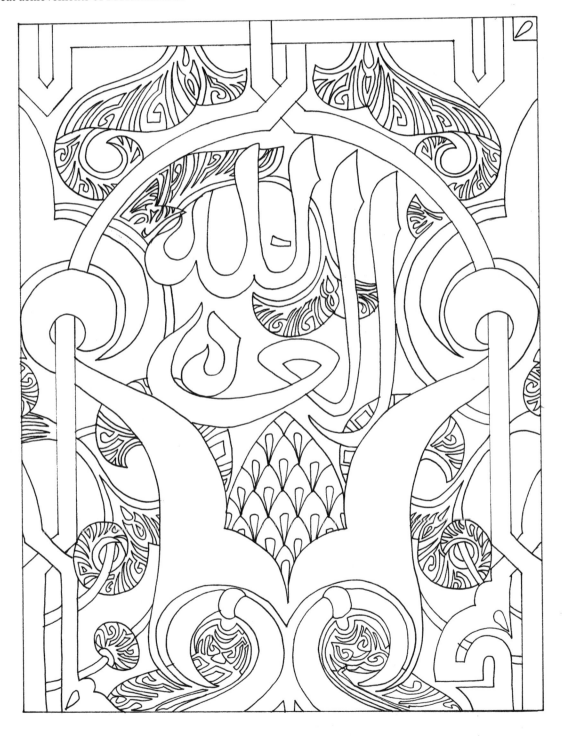

Arabesque

The arabesque was based on the organic floral swags and scrolling tendrils of the late Greco-Roman and Byzantine ornament. Under Muslim patronage, these once decorative vines took on the surging of a pioneering culture.

Arabesques or vine scrolls are associated with the embellishment of religious as well as secular objects and architecture. Many elaborate styles form different periods and places enliven surfaces with fascinating, rhythmic and never-ending progressions of vegetal stems, leaves, blossoms and flourishes, often concealing animate figures and tiny faces.

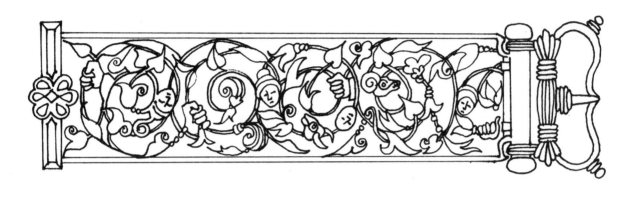

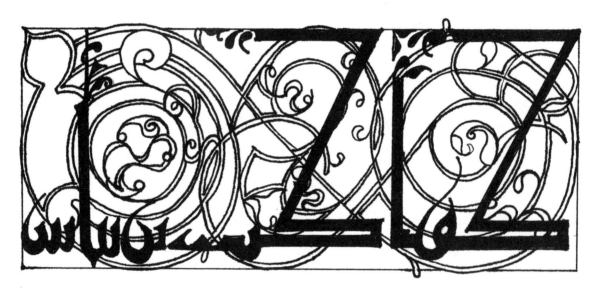

Geometry

Muslim designers also composed infinite variations based on geometric patterns. Compelling in perfection of proportion, intricacy of rhythms and in flickering changes seen in tessellating patterns, these crystalline configurations have affinities to scientific and mathematical speculation, considered to be Islam's greatest contribution to human knowledge. Men capable of navigating deserts by the stars--or of locating the precise direction of Makkah for prayer--also learned how to determine square roots of numbers and devised decimal fractions, geometry and trigonometry. Indeed, the term "algebra" is derived from the Arabic term al-jabr wa'l-muqabala, which means "breaking and reconstitution," and the scholar al-Kwarizmi has lent his name to the term "algorithm."[1]

[1] Welsh, Stuart Cary. *The Islamic World*, Introduction, page 9. New York: Metropolitan Museum of Art, 1987.

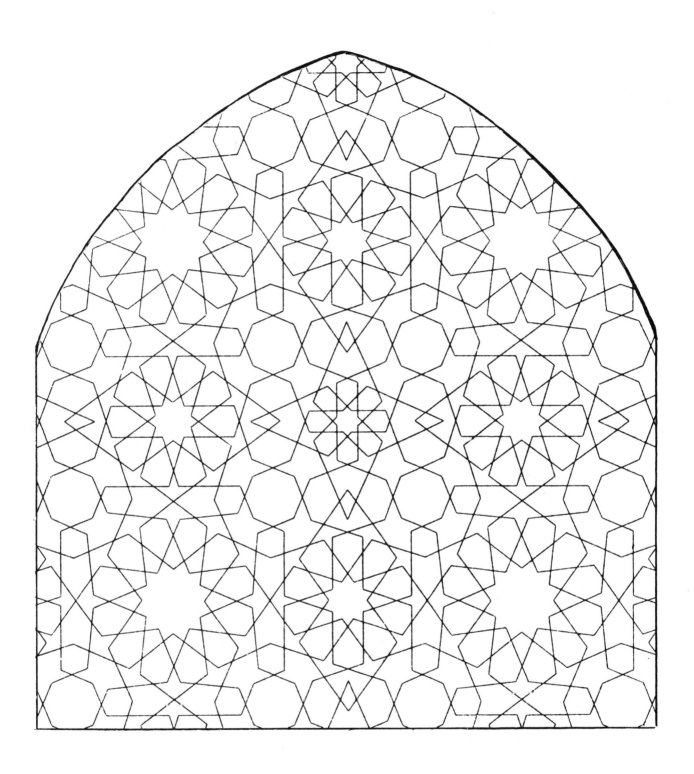

Figures

The representation of living beings causes particular difficulties in the discussion of Islamic art. The matter is complex, but the condemnation of idolatry is absolute. Therefore, the representation of animate beings is absent in religious architecture and literature and omitted from colleges and tombs. However, figurative motifs are abundant in secular works, whether rendered or half concealed as ornament. In keeping with the context of two-dimensional design, all figures are rendered in pure colors, with no indication of light and shadow. Deep space is not alluded to and neither figure nor ground diminishes in size.

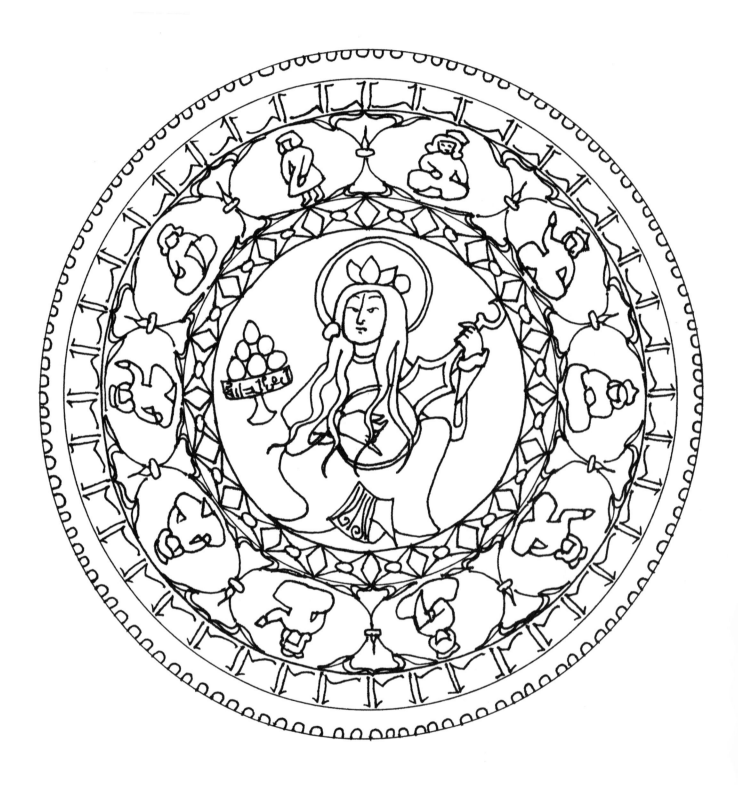

When and where the making of glass was begun has yet to be determined. It appears that core-formed vessels were produced in both Mesopotamia and Egypt from about 1500 BC on, and that glass beads and jewelry inlays imitating precious and semi-precious stones were made there even earlier. In fact, the blowpipe, a tool used since the first millennium B.C., was invented in Syria and revolutionized glassmaking by making mass production possible.

Islamic glass has been greatly admired in the West for centuries. Muslim craftsmen made major contributions to the art of glassmaking--most notably, luster-painted glass, relief-cut glass and the renowned enamel-painted glass. During the middle ages, splendid enamel-painted objects found their way to Europe, where they were prized and took their place among precious works of art in the great church treasuries. Mosque lamps, beakers, vases and other vessels attest to the creative energy of Egyptian, Syrian and Persian craftsmen at the zenith of medieval glass-making. The Venetian glassmakers and others in Europe were indebted to the Islamic tradition for many of their techniques and designs. Later, in America, Louis Comfort Tiffany's famed Favrile glass in the "Saracen style," with its shimmering iridescence and flowing contours, was directly influenced by glass from the Muslim world. The original function of surviving examples of Islamic glass cannot always be identified today, but whether the objects served as mosque lamps, jewelry, coin weights, vessels for beverages, cosmetics or perfume, their universal aesthetic appeal endures.

Islamic glass objects are enlivened with elaborate bands of calligraphy, intricate figural friezes, delicate floral and geometric motifs. Mosque lamps were regularly inscribed with the "Light Verse" from the Qur'an, making reference to divine light. Secular or courtly pieces were frequently embellished with figural scenes. These designs, painted in red, blue, green and white enamels as well as gold, were fused to the glass surfaces in the firing process. Their appealing shapes and colors reflect the unerring sense of design characteristic of Islamic art.

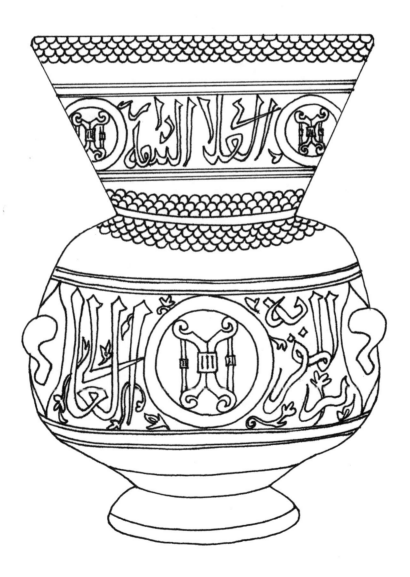

Manuscripts

Manuscripts were often sumptuous objects--masterpieces of artful design and construction. Every aspect of a courtly manuscript--the binding, the paper, the calligraphy and illumination—reflects painstaking craftsmanship. Stamped, molded, gilded or painted designs enhanced the exteriors, while marblized paper, cut paper filigree or fabrics lined the interiors.

Over the centuries, varying types of manuscript styles evolved. In the central and western parts of the early Islamic world, illustrated texts were scientific or technical in nature, embracing treatises on plants, animals and ingenious mechanical devices among others. Poetic manuscripts were quite popular, and during later eras, were filled with painted scenes and historical texts depicting important events, lively portraits and contemporary political and cultural gatherings. The production of manuscripts utilized the combined efforts of author, calligrapher, illuminator, painter and bookbinder. Today, the manual production skills are replaced by lithography, photography and typesetting. While this makes books readily available in multiple copies, it has also brought an end to an illustrious artistic tradition that is unlikely to be surpassed by modern technology.

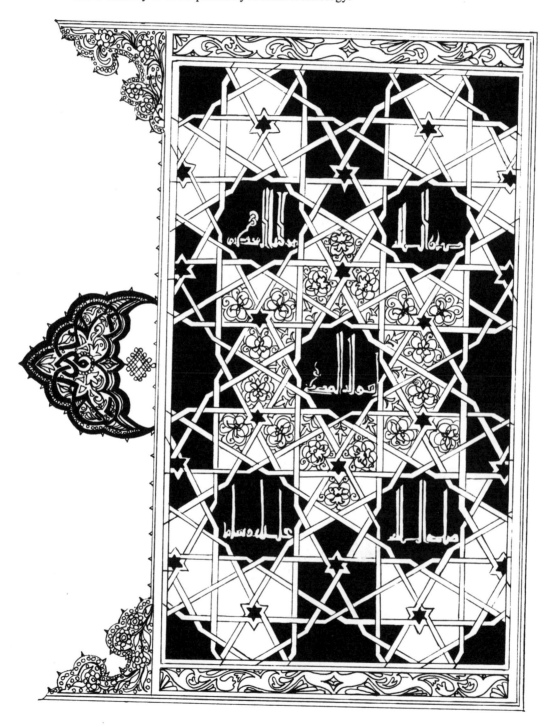

Metalwork

Some of the most luxurious objects of Muslim craftsmanship are executed in metal, inlaid with silver and gold. The artisans traced glittering vignettes of courtly activities, fascinating abstract patterns and varied styles of Arabic script. They lavished their talents on all types of objects—basins, ewers, candlesticks, pen boxes and incense burners.

The production of costly pieces is part of a long history of metalworking in the Islamic world. With great expertise, Muslim craftsmen employed bronze, brass, copper and steel for artistic and utilitarian purposes. While silver and gold were used with delicacy and refinement as inlays, surviving objects formed solely from these precious substances are rare.

Bronze objects were cast since the early centuries of Islam. This practice of casting objects allowed artisans to enliven their works with varied relief ornamentation. In addition to casting, metal surfaces were engraved, embossed or perforated with lattice work.

The metalworkers' great artistry and technical expertise are also evident in the weapons and fittings of military garb. Finely honed blades were often set in hilts embellished with inlaid or engraved inscriptions and ornamentation. Jeweled or enameled handles and scabbards of some swords and daggers convey the drama of ceremony rather than of battle. Standards, shields, maces, helmets and drums were frequently enhanced with calligraphy and intricate designs.

Scientific instruments used for astronomical calculations were also made of metal. Astrolabes, quadrants and globes, created for a learned clientele, were executed with great precision.

While the monetary value of most Islamic metalwork lies in its precious inlays and its beauty, the intrinsic value of coins is more significant. The viability of a country's currency depended on the purity of the metal. Coins were struck in silver, gold and copper and ornamented with the calligraphy which proclaimed the Muslim faith.

Metal, the material of money, arms and sumptuous objects, was also the medium of commercial exchange, of ceremony and of power. This encouraged the artistry of the craftsmen, and their accomplishments were of the highest order. Whether inlaying a candlestick or striking a coin, the Muslim metalworker exercised both aesthetic finesse and technical expertise.

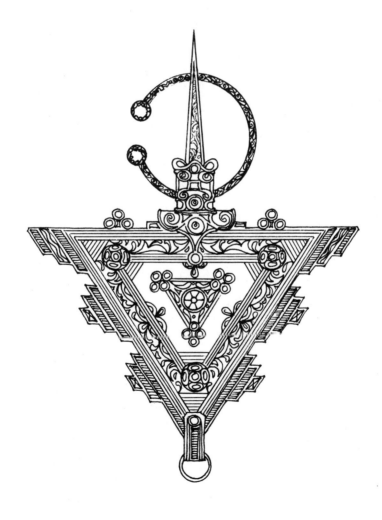

Pottery

Clay is a common substance, but invested with the breath of life. Clay objects formed by Muslim craftsmen exemplify the remarkable ability of the artisans to create beautiful pieces with modest means. Over the fourteen centuries of Islam, a wide variety of objects has been fashioned from clay: bowls, jars, boxes, small tables and wall tiles. Even modest items exhibit flawless design and sophisticated ornamentation. The designs that embellish these objects reflect the full range of motifs associated with Islamic art. Incised, molded or painted, the glazed wares show the love of varied colors and textures seen in other media. Geometric and vegetal ornamentation is sometimes linked to the shape of the piece, and sometimes spread over the surface in an endless pattern. Calligraphy also appears in many styles and combinations. Some pieces decorated with figural designs show scenes from popular stories, with an array of pleasant literary or narrative associations.

Perhaps the most distinctive and prestigious pottery made in the Islamic world was luster ware. The rainbow colors reflected from the surfaces of luster ware resulted from a complex and expensive process of double-firing. Produced in different centers from Persia to Spain, luster remained a characteristically Islamic technique. Examples of luster ware abound with geometric patterns, figural decoration, meandering vines and calligraphy.

Muslim craftsmen also drew inspiration from the pottery of other countries, as well as local styles. The decoration of a tenth-century plate from Persia may be confined to a single line of black calligraphy, a sixteenth-century plate made in Iznik, Turkey exhibits colorful floral motifs, and enormous vases made in Spain display flaring handles. Seeking to refine their objects in quality and decorative effect, Muslim potters experimented with different shapes, materials and glazes and made significant technical advances, while investing these creations with their own spirit and unique designs.

Textiles

From the hides of camels and the wool of sheep and goats, ancient shepherds and bedouin created tents, bags, saddles, rugs and clothing. The very oldest known woven remnants have been found in Egyptian tombs. With the advent of Islam, rug weaving spread from bedouin to cottage industries, to town and city workshops and finally to the creation of grand court carpets made for the palaces of royalty.

Islamic carpets found their way to Europe through trade routes established during the Middle Ages and became so popular in the West that they could be found in castles and cathedrals throughout the entire European continent and beyond.

Along with carpets, costumes made by Muslims living all over the world have a particular traditional distinction and beauty. Each region, from China to America, has its own unique approach to costume design; the topic is much too vast to discuss or illustrate in so few pages. Carpet designs are usually visually organized in four basic patterns: those with repeat designs, those with medallions, those that are directional in design and those with scenic designs of animals, architectural elements, vines and floral motifs.

Symbolism

The carpet designs illustrated here utilize the same motifs found in other Islamic arts, which are calligraphic, geometric, floral and figurative. Most of the carpet designs exhibit regional symbolism and iconography, such as dragons of Asia, tulips of Turkey or eight-pointed stars of Morocco. However, for the most part, the exact meanings of these designs are virtually unknown in the West. There are recognizable animals, birds, human figures, combs, samovars, lamps and even architecture. Yet, while conscious symbolism may have shaped the carpet designs, it is difficult to establish a specific meaning based on Western ideas, because this would impose a set of thought forms on another culture. The West has given titles, nicknames and categories to the designs, but these bear no root meaning of the carpet-makers.

The Visual Organization of Islamic Carpet Designs

1. Medallions. Designs resembling medallions are featured.
2. Repeat Patterns. These designs are usually geometric shapes repeated over the entire surface of the carpet.
3. Directional. These are usually prayer rugs. The central design represents the Amir Niche, found in the Masjid, and indicates the direction of Makkah. Smaller prayer rugs are used by individual Muslims to kneel upon in prayer. These rugs may also have a design of a "mosque" lamp in the center top of the niche. Directional carpets are those in which the designs can be viewed correctly in only one direction.
4. Scenic. Many different scenic designs can be found, but usually they are of animals, stylized forests or oases with rivers, ponds or lakes, reminiscent of Paradise Park.

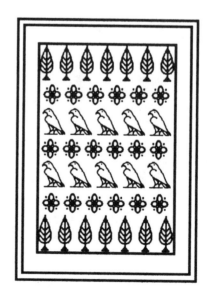

Conclusion

The character of Islamic art arises from the tensions created by its geographical and cultural background—a background which, with its aesthetic consequences, can be expressed in shorthand form as a number of dualities: desert and oasis, nomad and settler, discipline and sensuousness, simplicity and complexity, straight lines and curved. To these simple propositions should be added the distinction between that which is specifically Muslim and that which merely falls within the Muslim cultural orbit, and—especially in the later periods—that which is a component part of Islamic art of long standing and that which has been adopted from abroad.

A second characteristic is a deep sense of order. Among other effects, this calms and refines the aesthetic dualities, such as contrasts between plainness and decoration. But it can hardly be said to be part of a dual system itself, since its opposite, the random effect—though not entirely absent in Islamic art—is rare. The sense of order is rooted in the Islamic view that everything that exists is willed by Allah and has its place in the divine scheme of things.

A third area which seems of importance for the character of Islamic art is its particular treatment of symbolism, or how meanings are conveyed. It seems that many features of Islamic designs tend to point beyond the world of appearances to the eternal world, and symbols are often implied and general rather than systematic.

Today, there is a machine production of all types of products that were, in earlier periods, hand-crafted or built. Manuscripts have been replaced by the printing press; pottery by machine-made items reproduced in mass, with the use of molds; photographs have replaced paintings; handmade carpets have been replaced by those woven on computer-operated looms; and so on.

Thus, regarding Islamic arts and designs, only two disciplines remain truly creative in the late twentieth century, calligraphy and architecture. Though these may be devoted to secular purposes, and have been so in the past, they are the arts most closely associated with the faith of Islam. The conclusion must be that while some parts of Islamic designs have fallen away, the legacy is a Muslim core.[2]

Diane V. Horn

[2] Brend, Barbara. *Islamic Art*. London: British Museum Press, 1991.

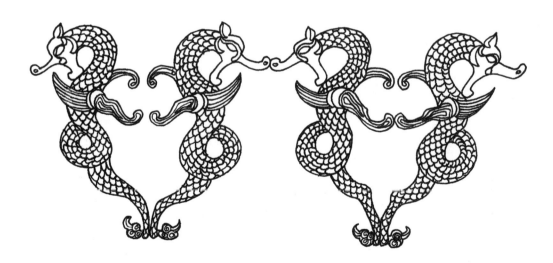

Contents

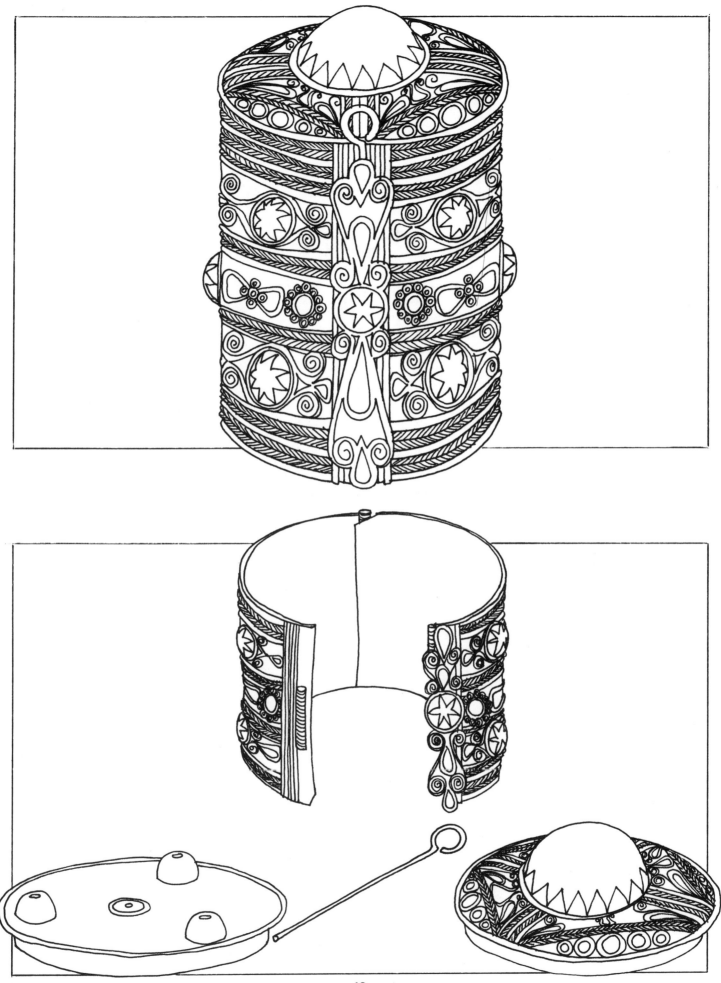

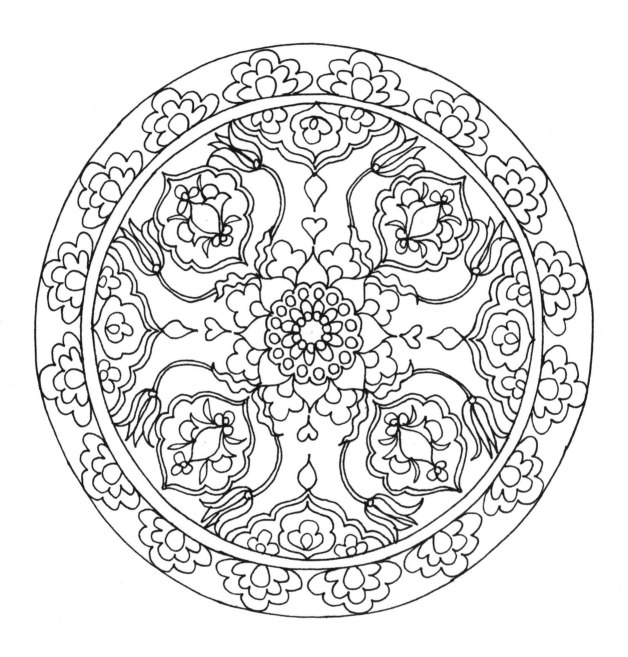

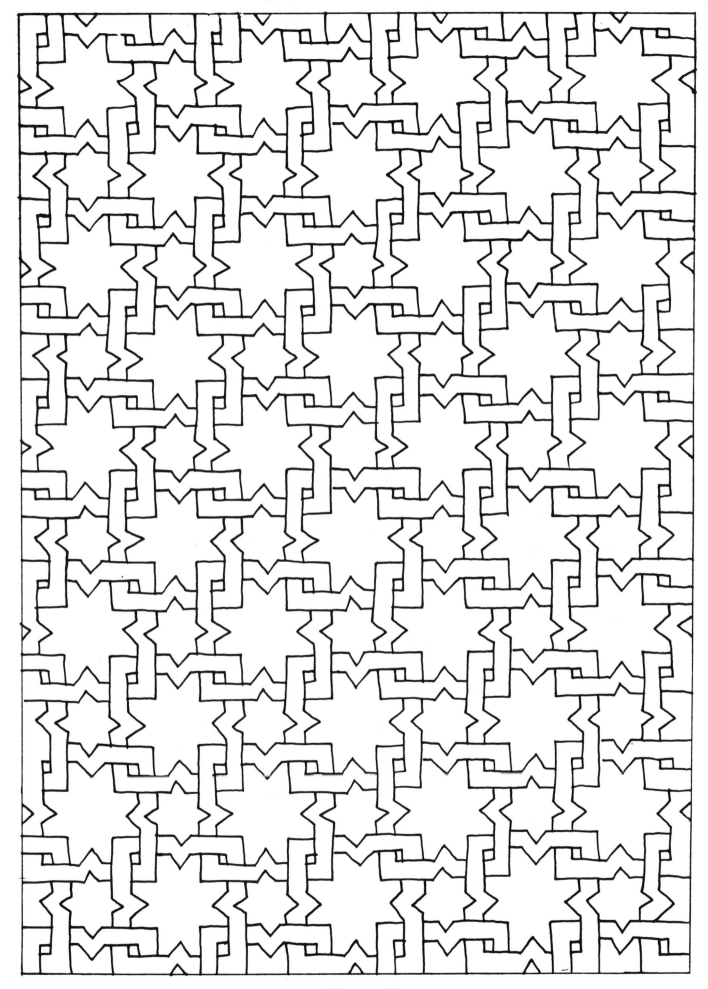

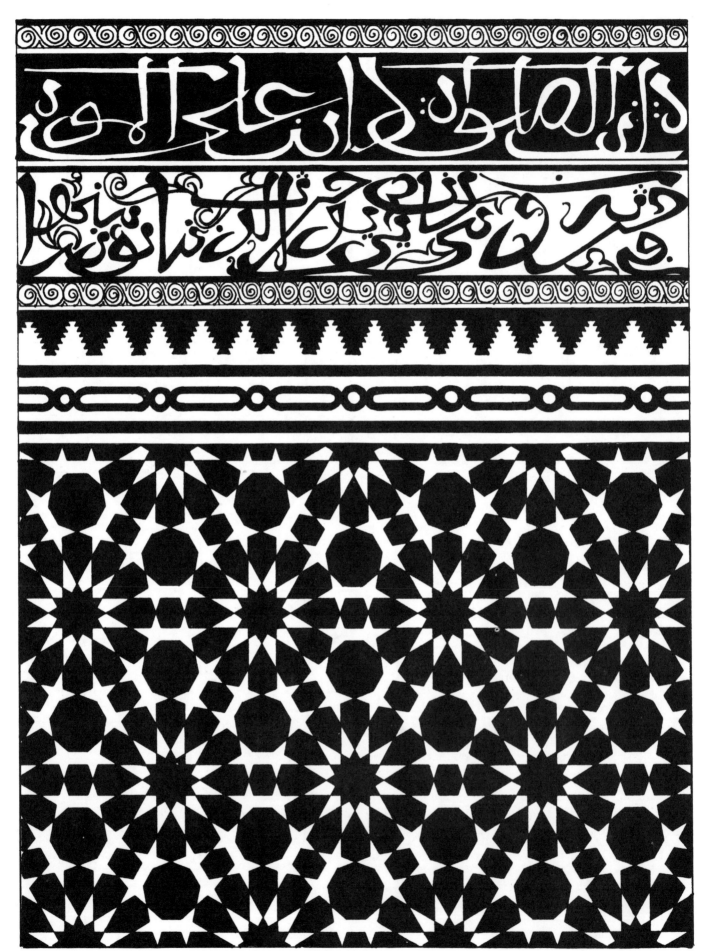

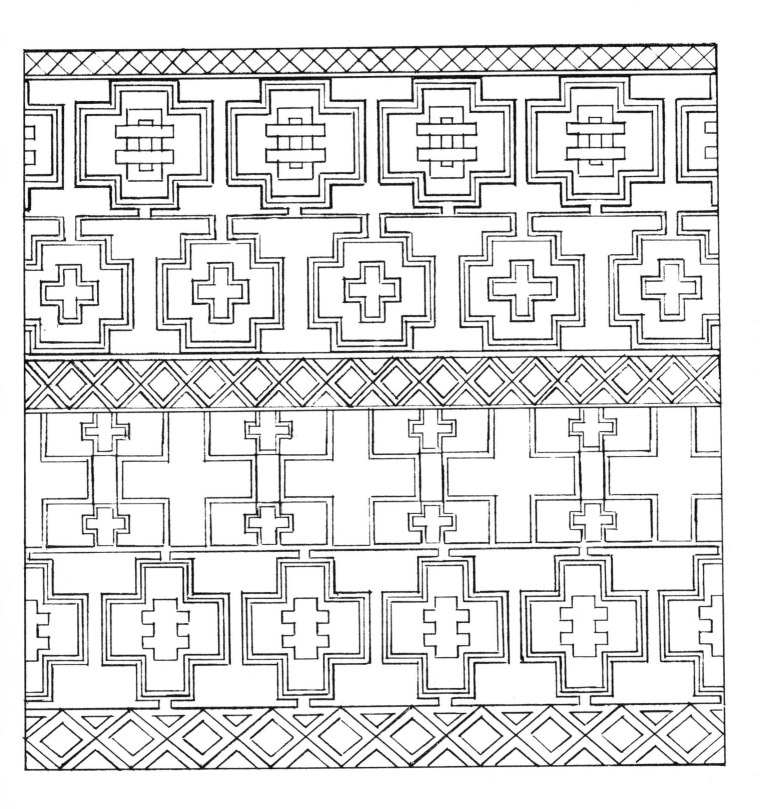

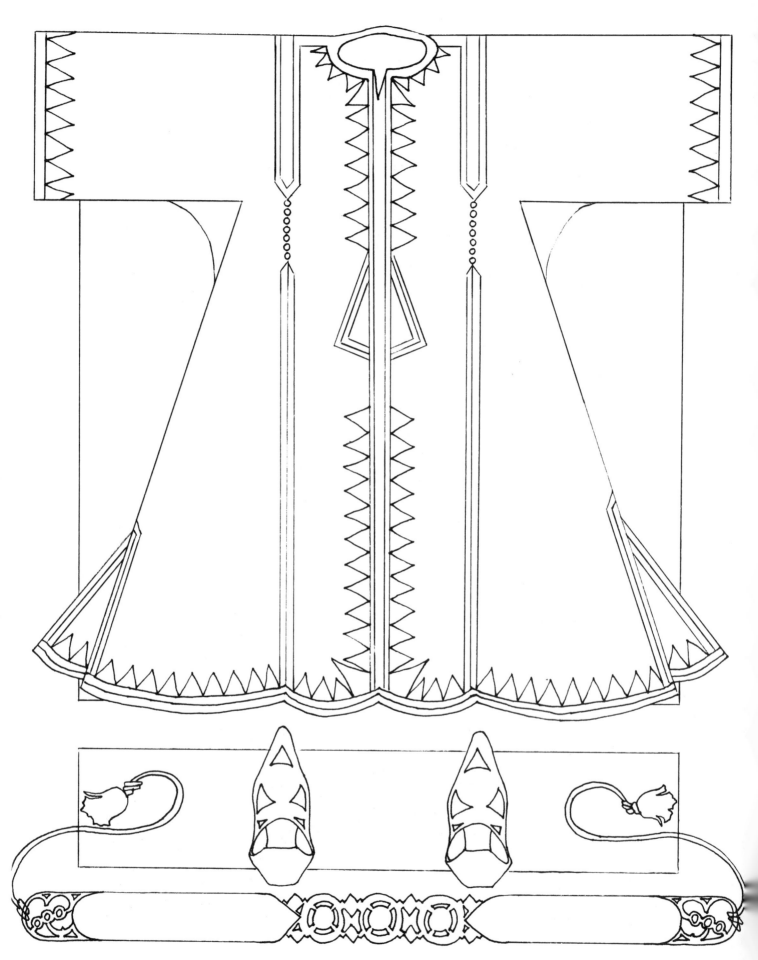

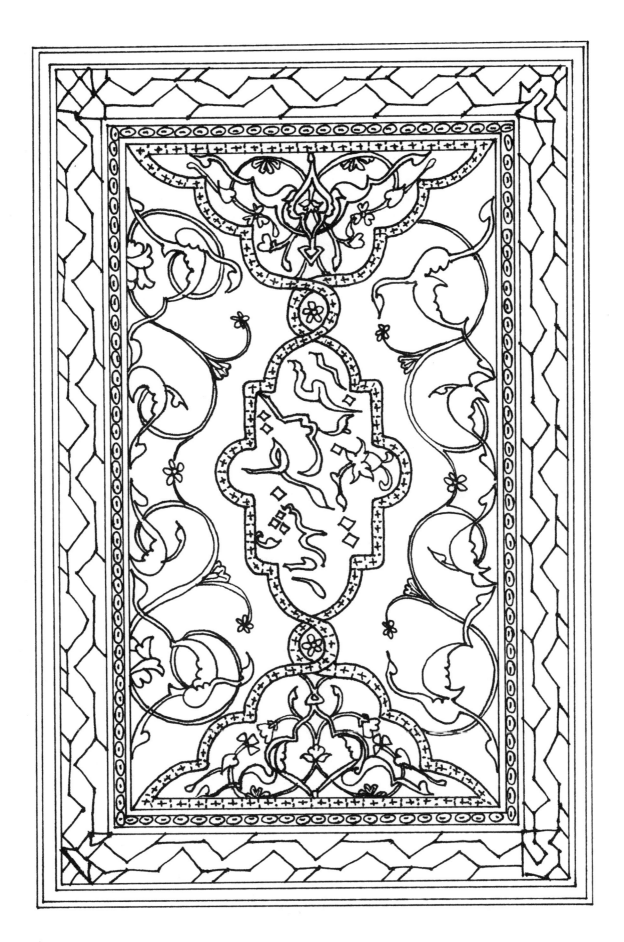

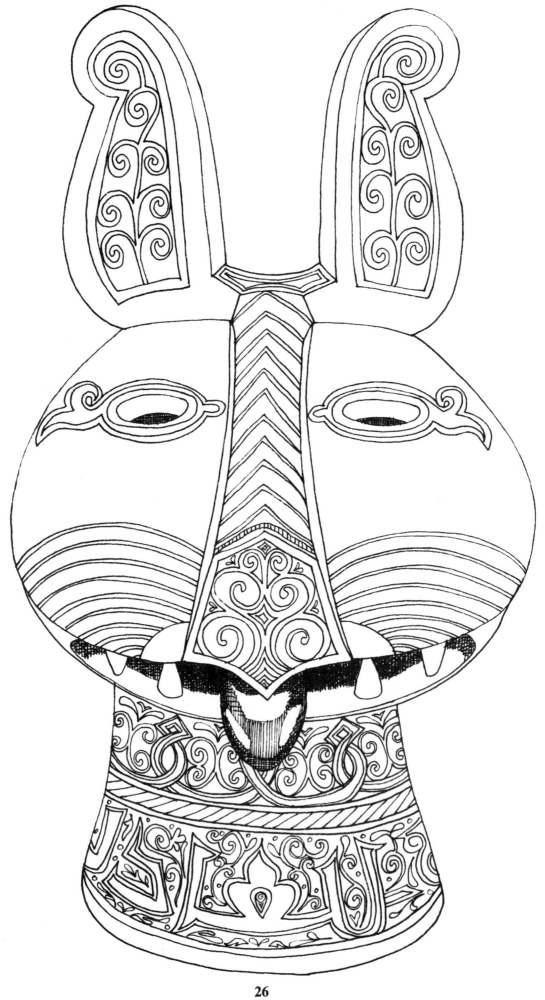

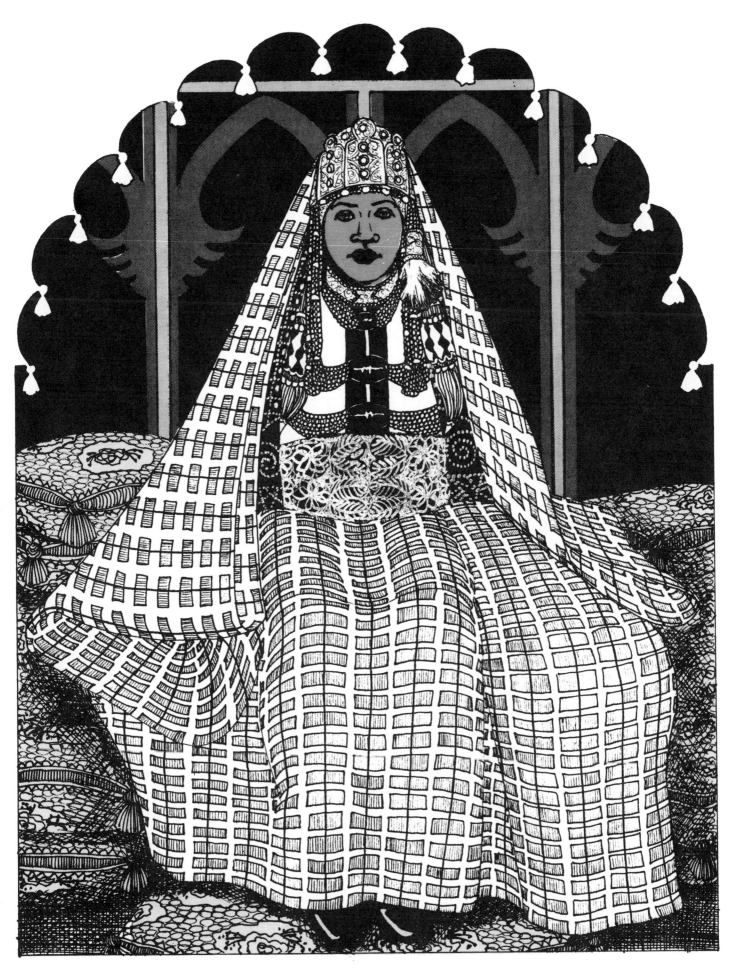

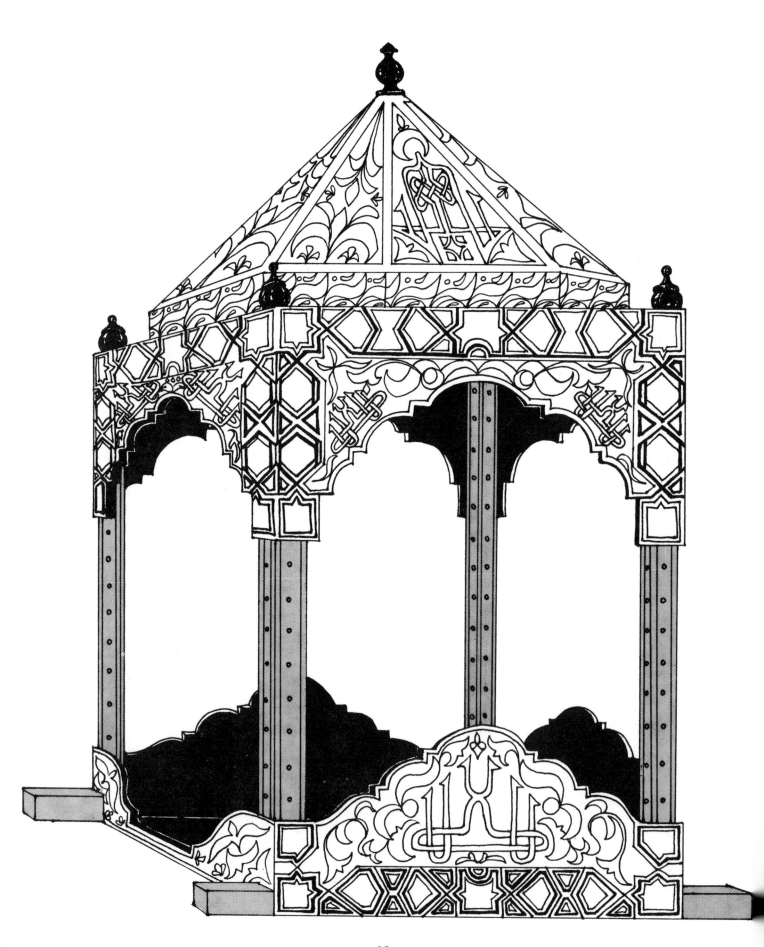

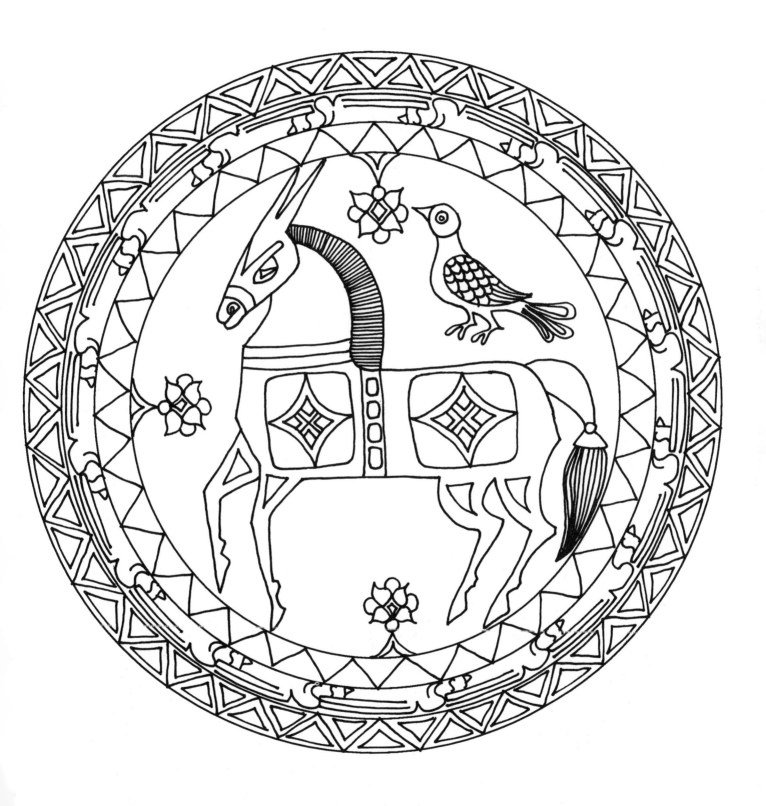

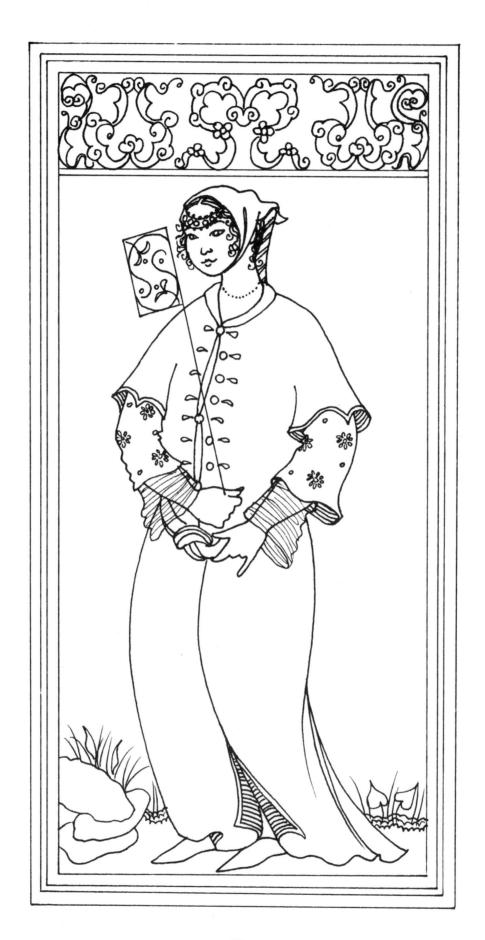

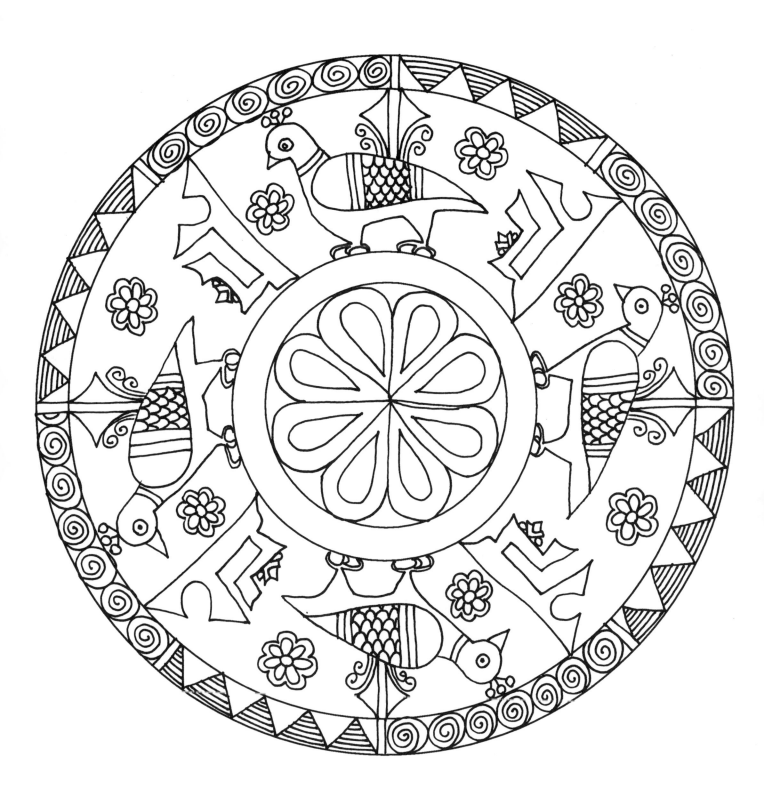

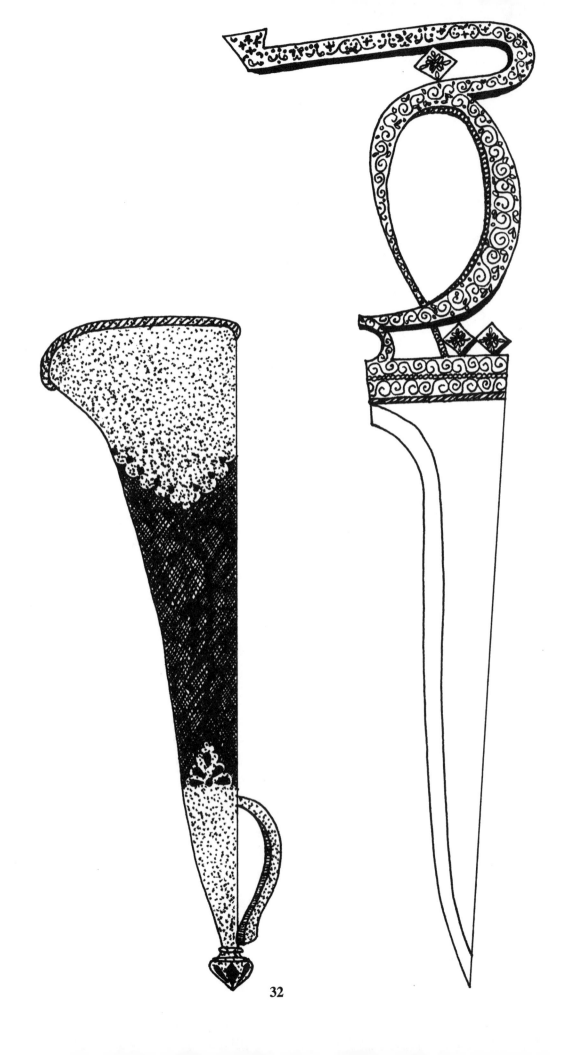

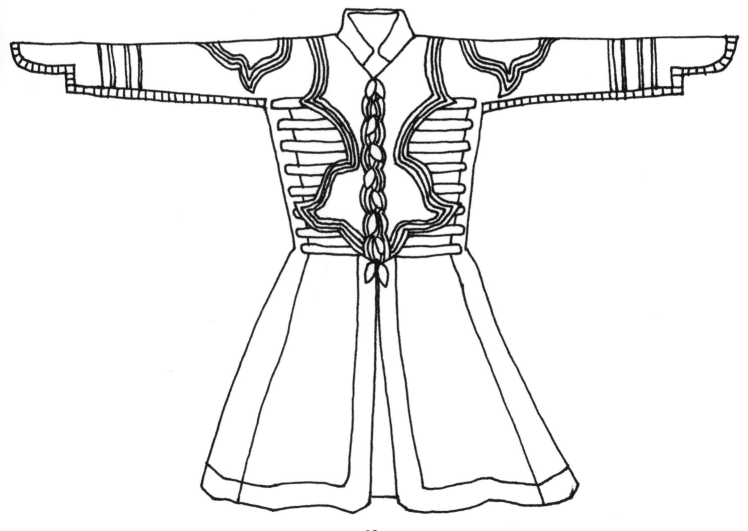

33

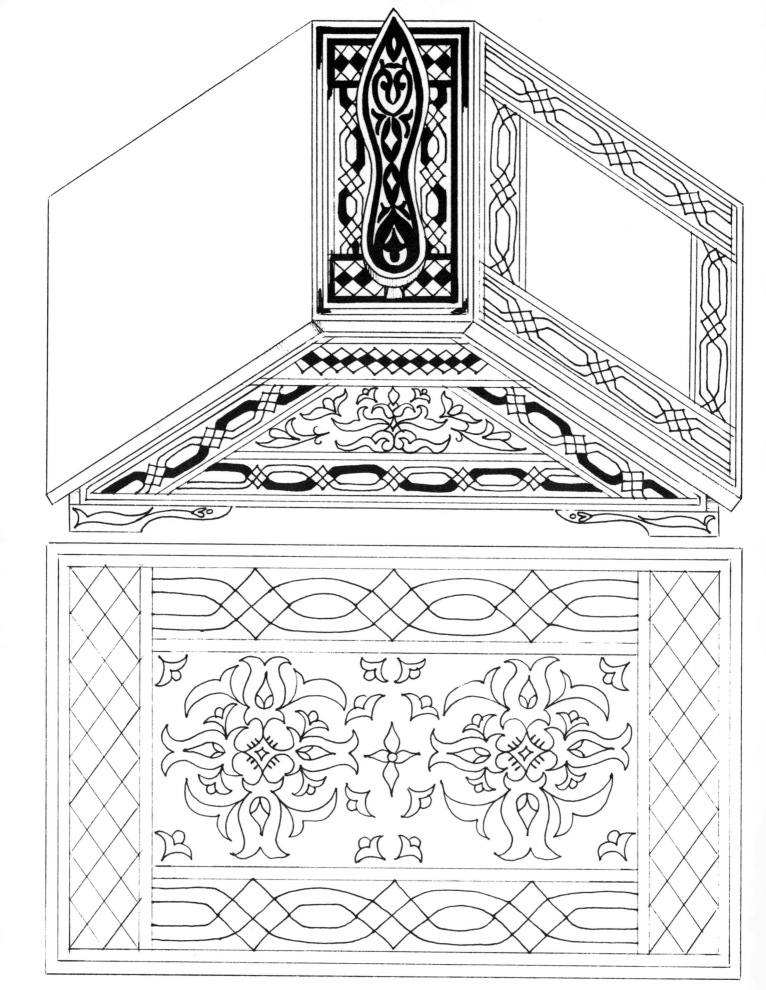

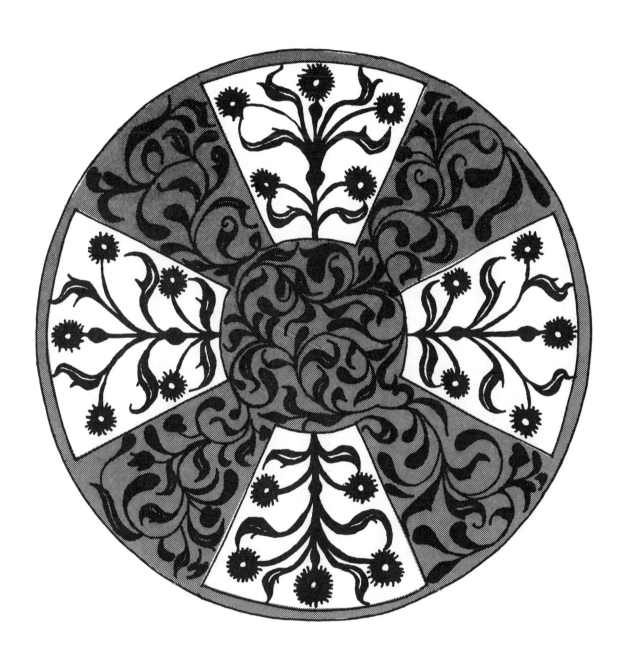

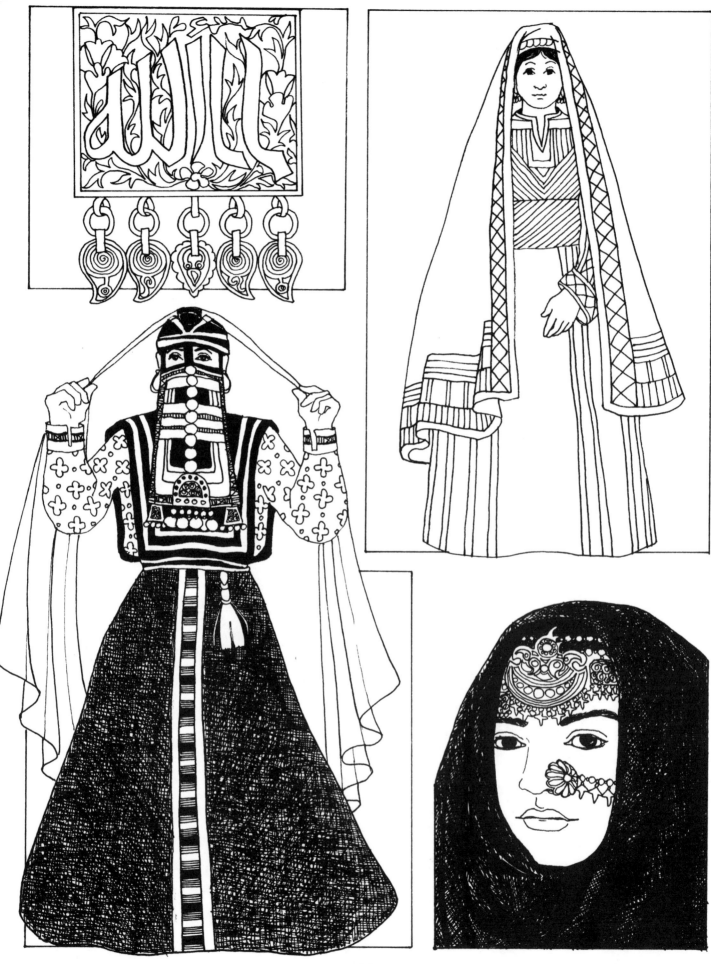

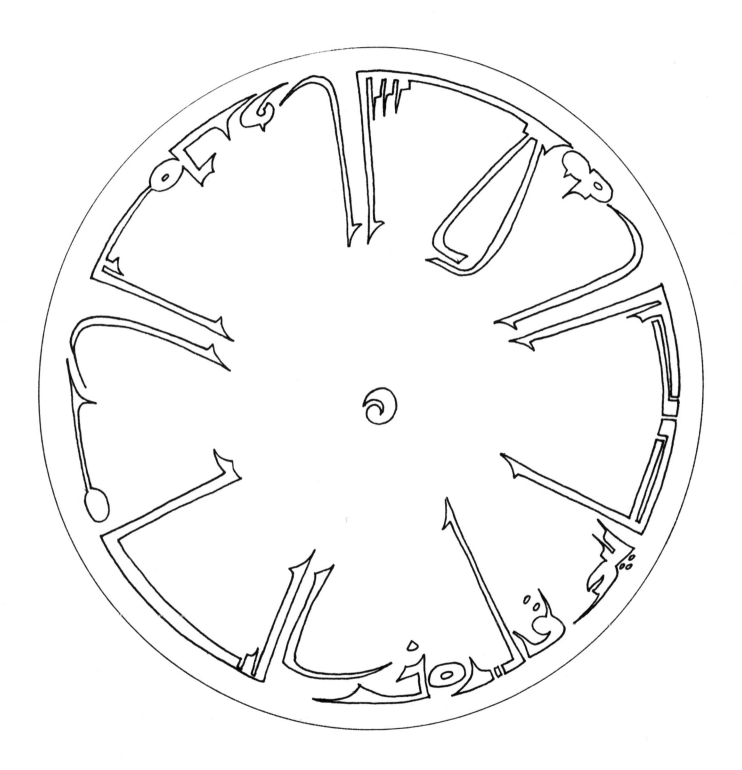

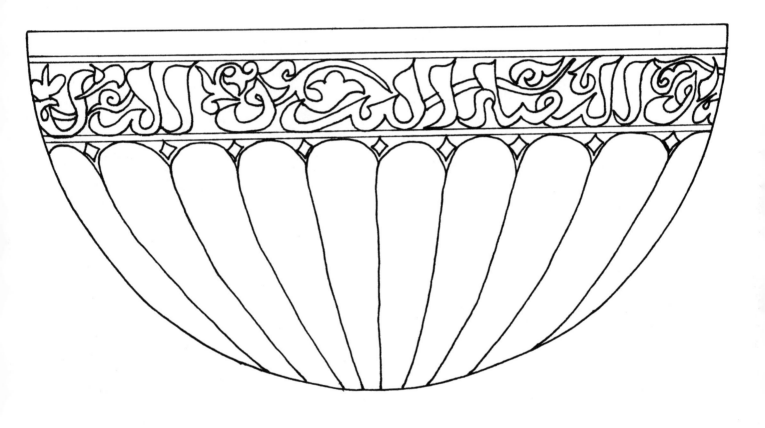

41

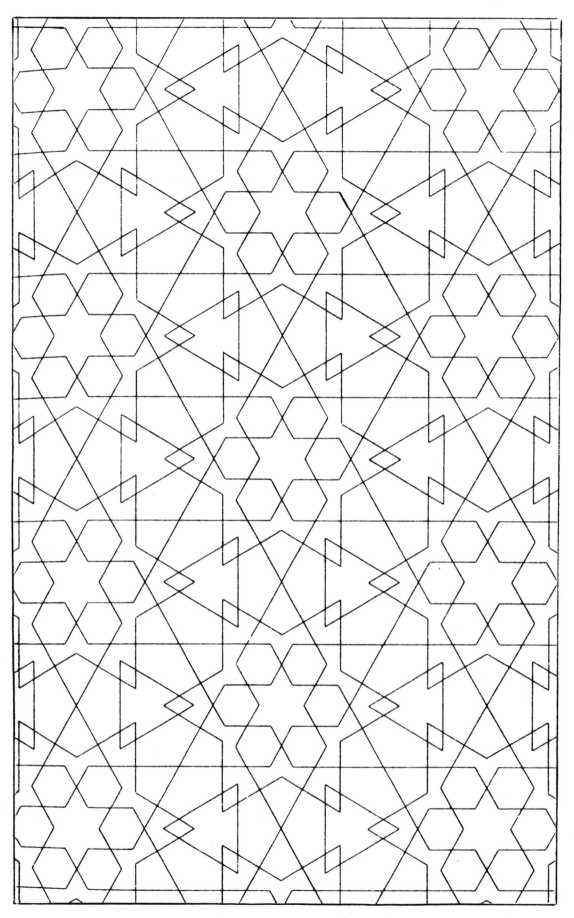

42

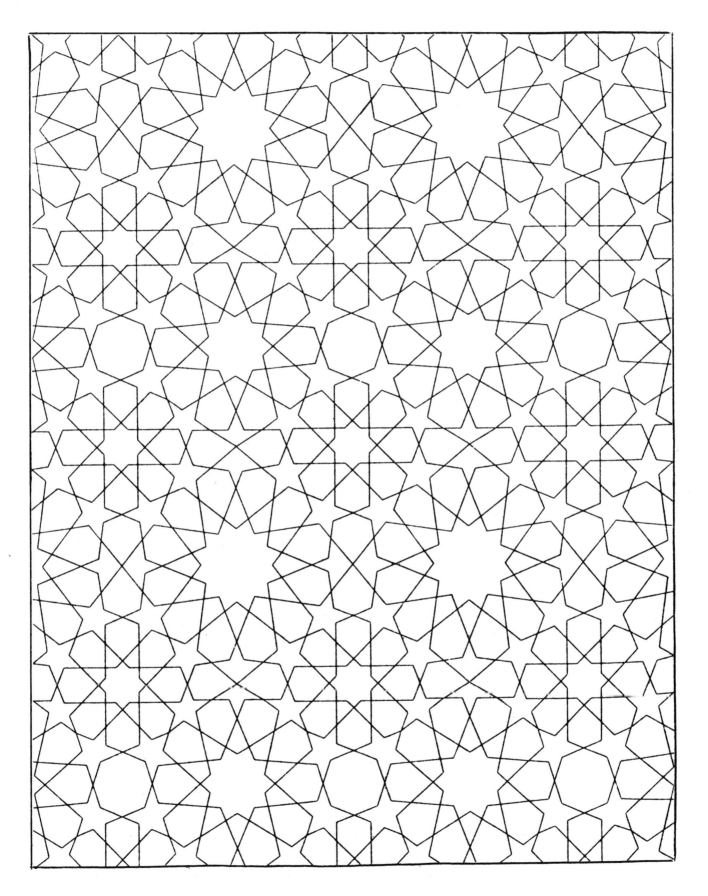

43

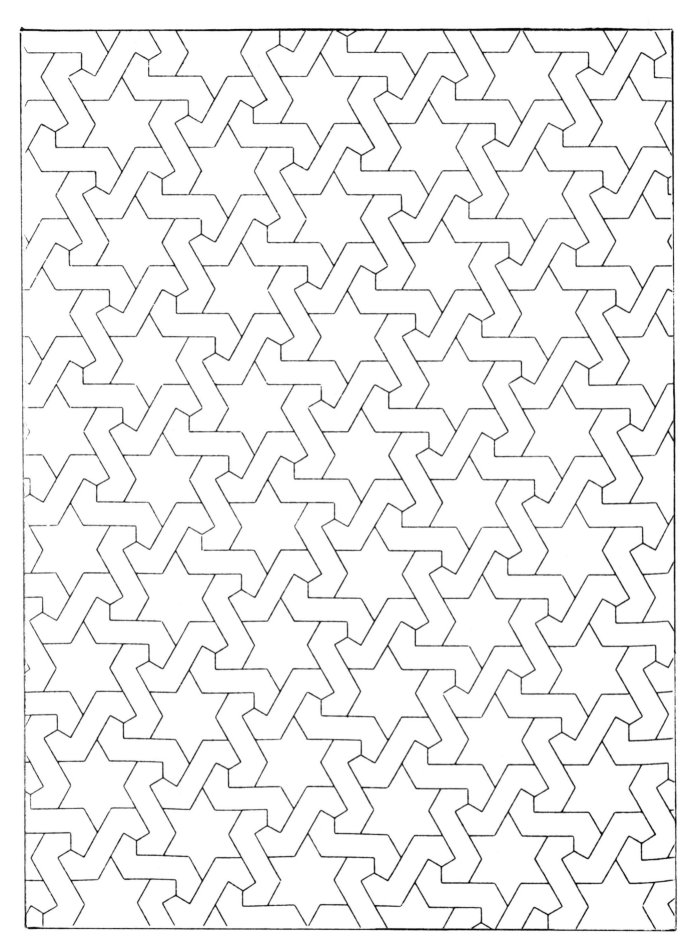

45

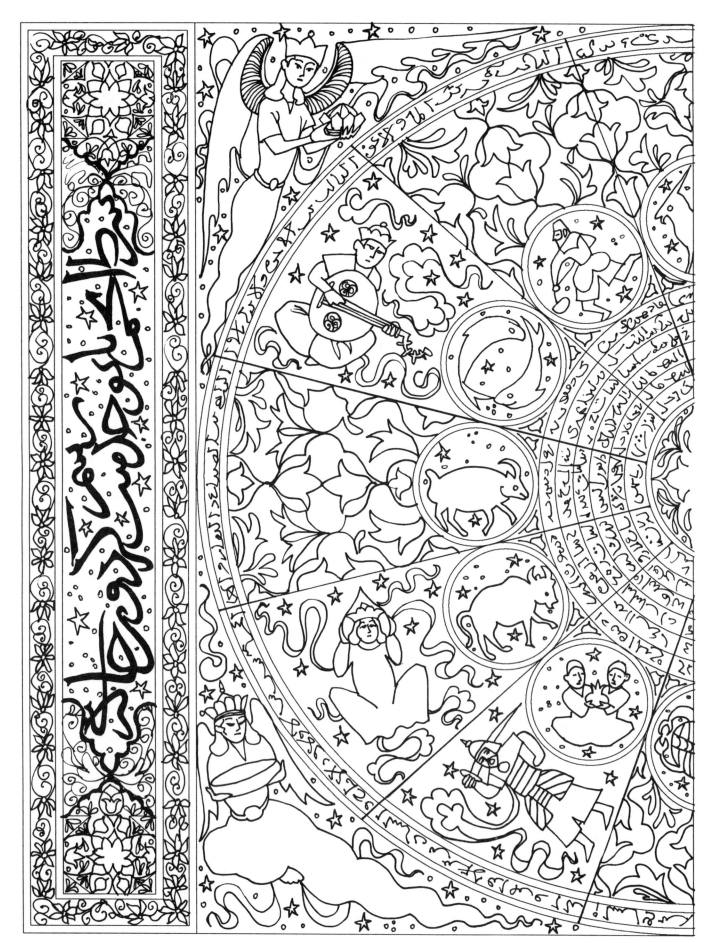

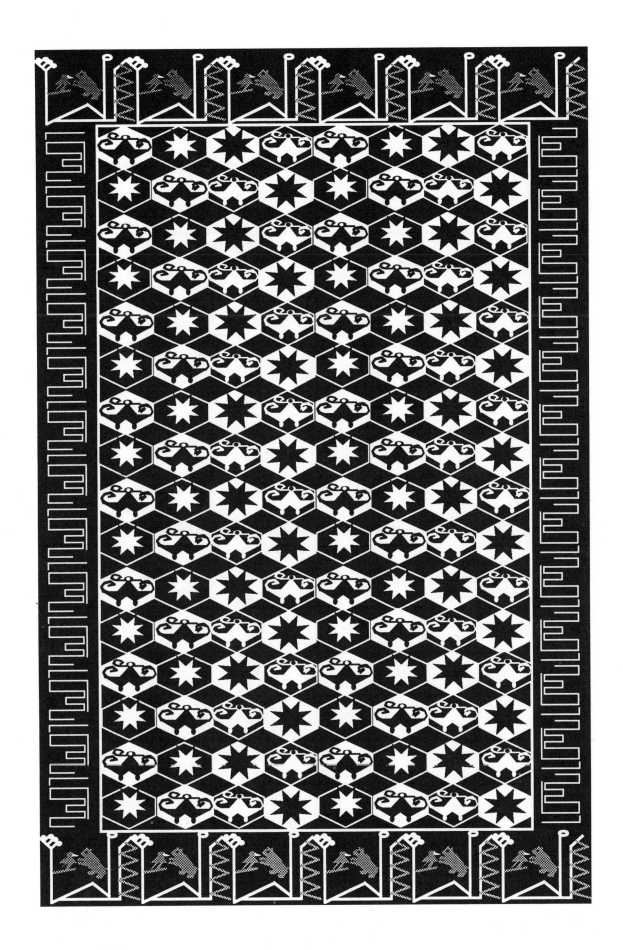

Bibliography

Atasoy, Bahnassi, Rogers. *The Art of Islam.* New York: Unesco/Flammarion, 1990

Brend, Barbara. *Islamic Art.* London: British Museum Press, 1991.

Edwards, Signell. *Patterns and Precision: The Arts and Sciences of Islam.* Washington: The National Committee to Honor the Fourteenth Centennial of Islam, Inc. 1982.

Ellis, Charles Grant. *Oriental Carpets in the Philadelphia Museum of Art.* Philadelphia: Philadelphia Museum of Art, 1988.

Stuart Cary Welsh. *The Islamic World.* New York: Metropolitan Museum of Art, 1987.

Jenkins, Marilyn. *Islamic Glass: A Brief History.* New York: Metropolitan Museum of Art, 1986.

Rice, David Talbot. Islamic Art. London: Thames and Hudson, reprinted 1993.

Thompson, Jon. *Oriental Carpets: From the Tents, Cottages and Workshops of Asia.* New York: Penguin Books USA Inc., 1993. (Formerly titled *Carpet Magic.* London: Barbican Art Gallery, 1983)

Designed by Barbara Holdridge
Composed in Times Roman by Creative Computer Solutions,
 Baltimore, Maryland
Printed on 75-pound Williamsburg Offset paper and
 bound by BookCrafters, Fredericksburg, Virginia